Blue slate

Violet

The
COLORED
PENCIL
ARTIST'S
POCKET
PALETTE

Instant, practical visual guidance on
mixing and matching colored pencils
to suit all subjects

Jane Strother

NORTH
LIGHT
BOOKS

CONTENTS

A QUARTO BOOK

ISBN 0-89134-549-3

Copyright © 1993
Quarto Inc.
First published in the
U.S.A. by North Light
Books, an imprint of
F & W Publications, Inc.
1507 Dana Avenue
Cincinnati, Ohio 45207

This book was designed
and produced by
Quarto Inc.
The Old Brewery
6 Blundell Street
London N7 9BH

THE COLORS

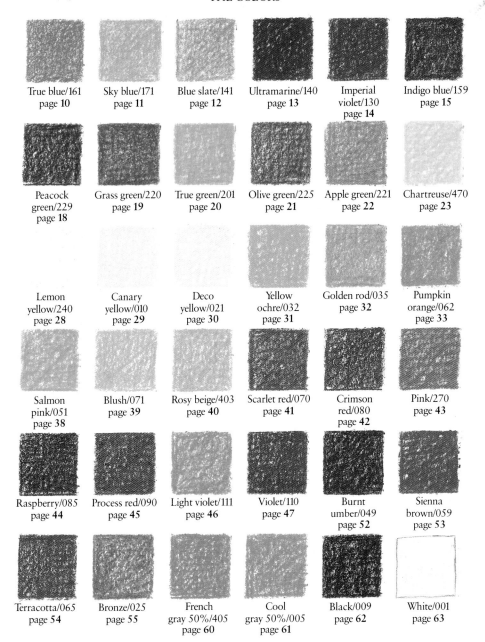

True blue/161
page **10**

Sky blue/171
page **11**

Blue slate/141
page **12**

Ultramarine/140
page **13**

Imperial
violet/130
page **14**

Indigo blue/159
page **15**

Peacock
green/229
page **18**

Grass green/220
page **19**

True green/201
page **20**

Olive green/225
page **21**

Apple green/221
page **22**

Chartreuse/470
page **23**

Lemon
yellow/240
page **28**

Canary
yellow/010
page **29**

Deco
yellow/021
page **30**

Yellow
ochre/032
page **31**

Golden rod/035
page **32**

Pumpkin
orange/062
page **33**

Salmon
pink/051
page **38**

Blush/071
page **39**

Rosy beige/403
page **40**

Scarlet red/070
page **41**

Crimson
red/080
page **42**

Pink/270
page **43**

Raspberry/085
page **44**

Process red/090
page **45**

Light violet/111
page **46**

Violet/110
page **47**

Burnt
umber/049
page **52**

Sienna
brown/059
page **53**

Terracotta/065
page **54**

Bronze/025
page **55**

French
gray 50%/405
page **60**

Cool
gray 50%/005
page **61**

Black/009
page **62**

White/001
page **63**

USING THIS BOOK

Colored pencils cannot be premixed as paints can, but rich and varied color effects can be built up by mixing on the working surface. The purpose of this book is to provide the colored pencil artist with an easy guide to over 800 color overlays, using both "dry" pencils and the watersoluble variety, which can create very painterly effects.

From the vast range of colored pencils available, we have chosen a selection of 36, and the charts show how this relatively small basic palette can be extended by mixing. The page by page chart layout provides instant visual information so that you can see at a glance how to achieve the mix you want. You may also discover some surprising new mixes and intriguing color contrasts.

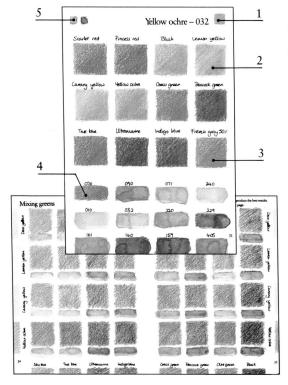

◀Each page features one of the 36 colors, referred to as the "main" color (1). For a visual guide to these see page 3. On each page, the main color is laid over 12 constant "basic palette" colors (2, and see opposite), which appear in the same order every time. The main color is also shown at the top of each page. Both "dry" and watersoluble pencils have been used for the charts. The former are referred to by name (3) and the latter by number (4). The symbols (5) denote various characteristics of the main color.

◀Special features focus on secondary colors (green, orange and purple), and provide useful mixes for browns. Such colors can, of course, be bought ready made, but it can be interesting to make your own.

THE BASIC PALETTE

The palette of 12 colors shown below provides a balanced range from across the spectrum. However, this is ony a starting point, and you may wish to add or substitute certain colors to alter the balance. For example, apple green, which is yellowish, might replace grass green, which has a blue bias.

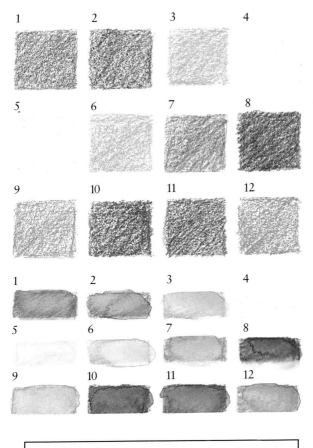

◄This is the basic palette used throughout the book, shown here without the addition of the main color. In the charts (see opposite), the basic palette colors are put down first and the main colors laid on top. The color mix varies according to which color is laid first. It is also much affected by the pressure of the pencil, and the charts have been graded light to dark to show something of these effects.

The names refer to the Berol dry pencils and the numbers in brackets to the Caran d'Ache watersoluble pencils.

1 *Scarlet red (070)*
2 *Process red (090)*
3 *Blush (071)*
4 *Lemon yellow (240)*
5 *Canary yellow (010)*
6 *Yellow ochre (032)*
7 *Grass green (220)*
8 *Peacock green (229)*
9 *True blue (161)*
10 *Ultramarine (140)*
11 *Indigo (159)*
12 *French gray 50% (405)*

REMEMBER
Each main color is featured on its own page. The basic palette repeats once on every page.

MIXING SECONDARY COLORS

The three primary colors, which are given this name because they can't be produced from mixtures of other colors, are red, yellow and blue. Pairs of these three colors, when mixed together, make the secondary colors – orange, green and purple. But it isn't quite as simple as this, because there are different versions of each of the primaries, and this affects the kind of mixture you make. The basic palette includes the two reds, yellows and blues shown on the simple color wheel below; notice how different they appear when you see them side by side.

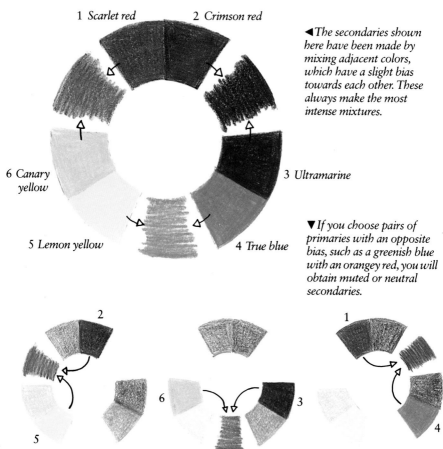

1 *Scarlet red*

2 *Crimson red*

◄ *The secondaries shown here have been made by mixing adjacent colors, which have a slight bias towards each other. These always make the most intense mixtures.*

6 *Canary yellow*

3 *Ultramarine*

5 *Lemon yellow*

4 *True blue*

▼ *If you choose pairs of primaries with an opposite bias, such as a greenish blue with an orangey red, you will obtain muted or neutral secondaries.*

Striking differences in color and tone can be achieved by overlaying the same two colors in different ways. Varying the pressure of the pencil point is an obvious way of affecting the depth of color, but the end result can also be affected by the order in which the colors are laid. Although the top color tends to be dominant, a light color can still make an impact when covered by a darker one. The colors used below are deco yellow and imperial violet.

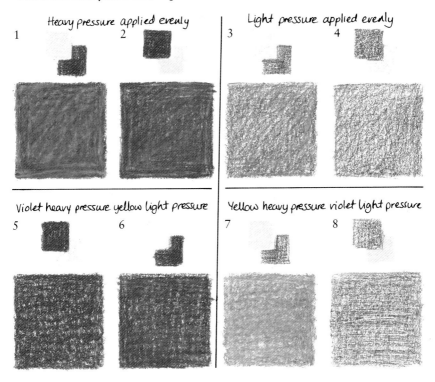

Top row Laying the lighter color heavily over the darker (1) has the effect of burnishing it (see page 8). The yellow laid below the purple (2) slightly modifies the darker color. Yellow laid as the top color (3) blends into the purple. It has a stronger effect when used first (4).

Bottom row Here (5) the yellow is almost lost. The yellow laid on top of the purple (6) lightens and slightly changes it. The yellow is strong (7) but still blends with the purple. When the yellow is used first (8) the two colors "sit" separately.

METHODS OF COLOR MIXING

There are a variety of ways in which colors can be mixed on the paper. The one you choose will depend on the effect you want to achieve. For example, you may want a smooth transition from one color to another or a thorough mixture of two or more colors. You may on the other hand prefer the livelier, more sparkling effect that comes from "optical mixing", where each of the colors used in the mixture can still be identified although the eye "reads" them as a third color. It is worth experimenting with different methods, and some of the many possiblilities are shown below.

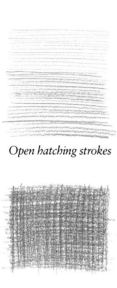

Open hatching strokes

Close hatching strokes

◀ *With hatching and crosshatching, linear marks are laid down side by side or across one another. You can build up tones as well as mixing colors "optically". The marks can be close together or left open, and the pencil point can vary.*

Even crosshatching

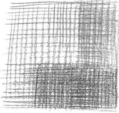

Varied crosshatching

◀ *Overlaying by shading produces a smoother blend, particularly if the colors are softened by rubbing with a tissue or rag. The pressure of the pencil point can be varied to fill the grain of the paper or leave areas of it visible.*

Colors shaded together

Shaded colors rubbed with tissue

Burnished with eraser

Burnished with white pencil

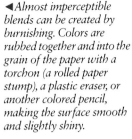Almost imperceptible blends can be created by burnishing. Colors are rubbed together and into the grain of the paper with a torchon (a rolled paper stump), a plastic eraser, or another colored pencil, making the surface smooth and slightly shiny.

◄ In these examples, colors have been laid down dry and then washed over with water, causing them to mix. More dry color can be laid on top if required with a brush or rag.

Heavy blue over heavy red

Heavy red over heavy blue

Heavy blue over light red

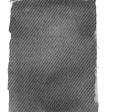

Heavy red over light blue

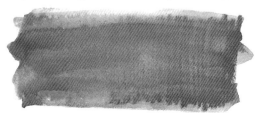

Graded blue to red

THE SYMBOLS

There are two symbols on each page. The left-hand symbol relates to the dry pencils and the right-hand one to the watersoluble.

 Permanent

 Normally permanent

 Moderately permanent

 Permanent

 Normally permanent

 Moderately permanent

9

True blue – 161

Scarlet red	Process red	Blush	Lemon yellow
Canary yellow	Yellow ochre	Grass green	Peacock green
True blue	Ultramarine	Indigo blue	French gray 50%

070	090	071	240
010	032	220	229
161	140	159	405

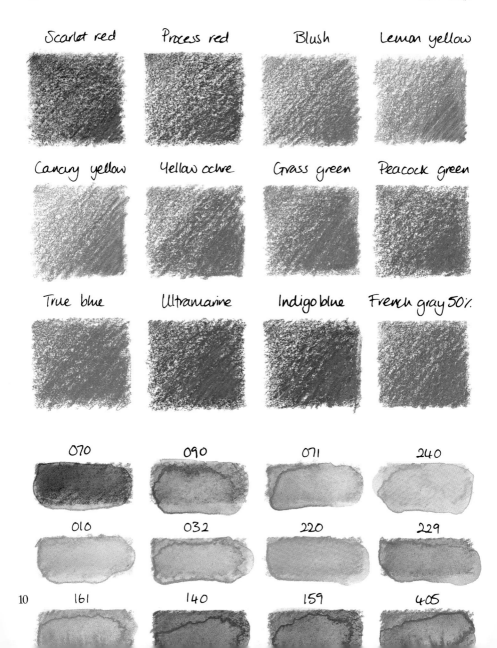

Scarlet red	Process red	Blush	Lemon yellow

Canary yellow	Yellow ochre	Grass green	Peacock green

True blue	Ultramarine	Indigo blue	French gray 50%

070	090	071	240

010	032	220	229

161	140	159	405

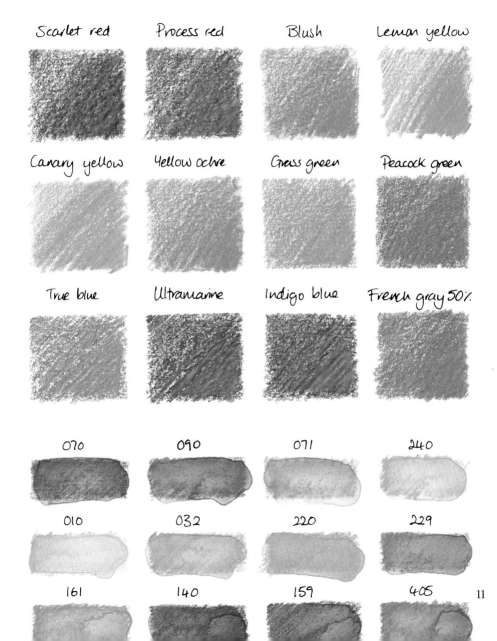

Blue slate – 141

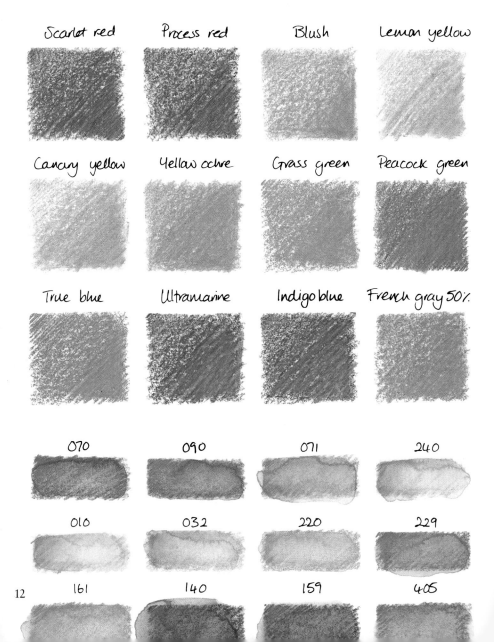

Scarlet red

Process red

Blush

Lemon yellow

Canary yellow

Yellow ochre

Grass green

Peacock green

True blue

Ultramarine

Indigo blue

French gray 50%

070

090

071

240

010

032

220

229

161

140

159

405

Ultramarine – 140

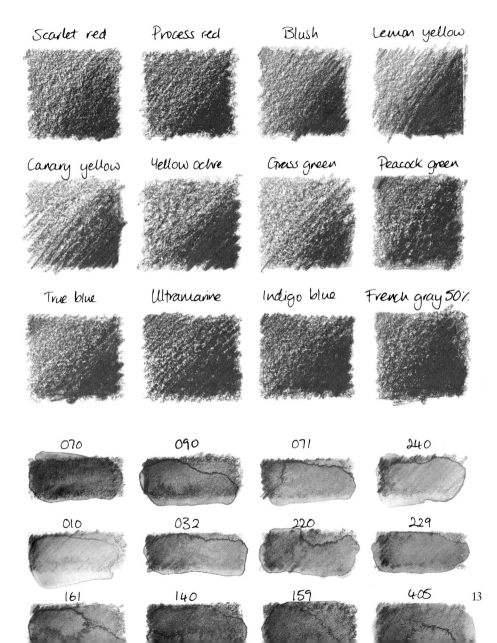

Scarlet red

Process red

Blush

Lemon yellow

Canary yellow

Yellow ochre

Grass green

Peacock green

True blue

Ultramarine

Indigo blue

French gray 50%

070

090

071

240

010

032

220

229

161

140

159

405

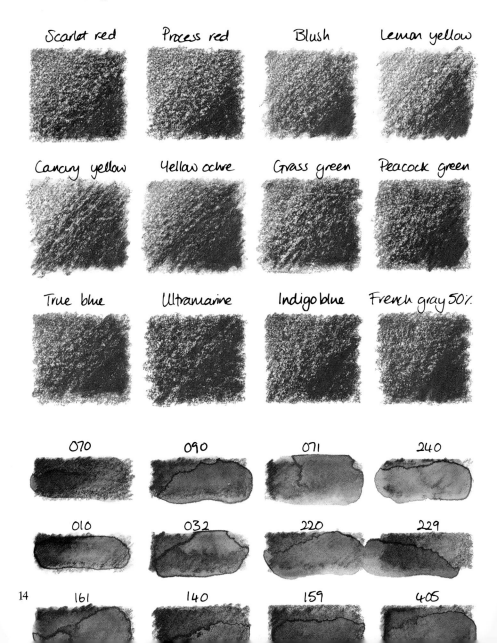

Scarlet red

Process red

Blush

Lemon yellow

Canary yellow

Yellow ochre

Grass green

Peacock green

True blue

Ultramarine

Indigo blue

French gray 50%

070

090

071

240

010

032

220

229

161

140

159

405

14

Indigo blue – 159

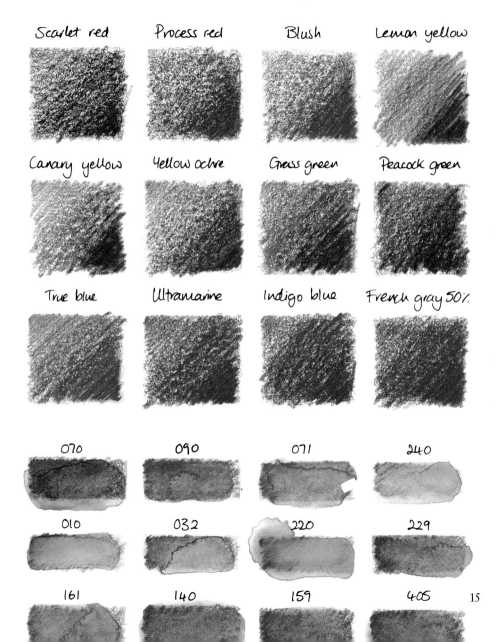

Scarlet red	Process red	Blush	Lemon yellow
Canary yellow	Yellow ochre	Grass green	Peacock green
True blue	Ultramarine	Indigo blue	French gray 50%

070	090	071	240
010	032	220	229
161	140	159	405

15

USING BLUES

Sue Lines – *Fishes*

14 × 11 ins

THE COLOR EFFECTS in this lovely delicate drawing have been built up throughout by hatching and crosshatching. Using fine lines and sharp pencils, the artist has achieved very subtle gradations of tone and graceful modeling of form. The consistency of handling unifies the picture as well as providing an extra decorative dimension.

▶ *The form of the seaweed has been developed by altering the pressure of the pencil point and gently manipulating the direction of the strokes.*

▼ *The shadows on the body of the crab have been made by overlaying yellow ochre with various browns and blues. The blues and blue-greens echo the colors in the background, while the warm colors and touches of violet help to "lift" the crab from the ground.*

▲ *A lively surface effect is made by crosshatching over the systematic diagonal hatching of the background. Some areas are sufficiently dense to read as a continuous tone.*

◀ *The pinks used for the seaweed on the left are important in the composition, echoing the star and the paler pink on the top of the fish's body. All the pinks have been kept slightly "cool", to blend with the overall blue color scheme.*

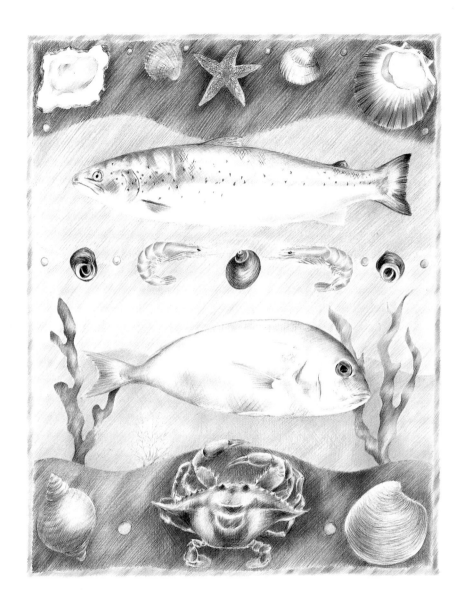

 # Peacock green – 229

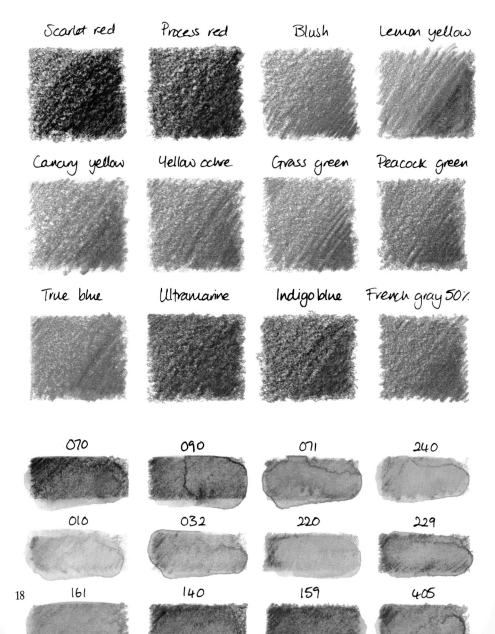

Scarlet red

Process red

Blush

Lemon yellow

Canary yellow

Yellow ochre

Grass green

Peacock green

True blue

Ultramarine

Indigo blue

French gray 50%

070

090

071

240

010

032

220

229

161

140

159

405

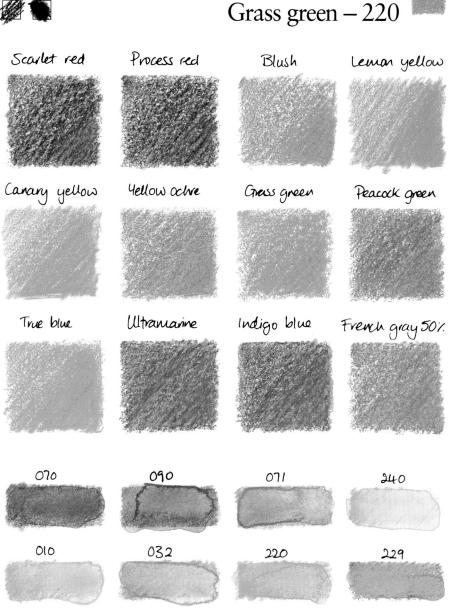

Scarlet red	Process red	Blush	Lemon yellow
Canary yellow	Yellow ochre	Grass green	Peacock green
True blue	Ultramarine	Indigo blue	French gray 50%

070	090	071	240
010	032	220	229
161	140	159	405

True green – 201

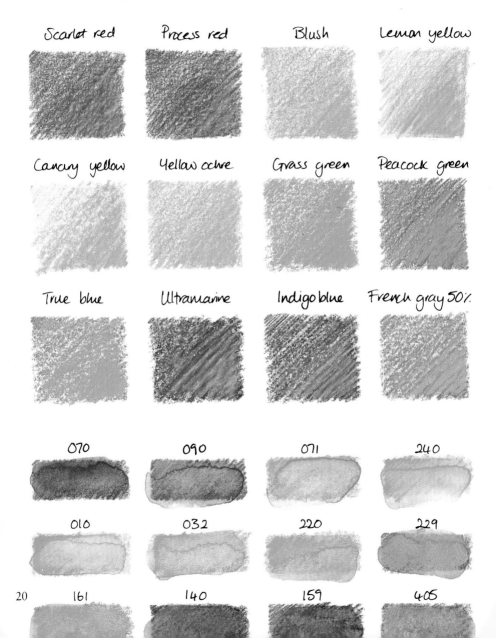

Scarlet red

Process red

Blush

Lemon yellow

Canary yellow

Yellow ochre

Grass green

Peacock green

True blue

Ultramarine

Indigo blue

French gray 50%

070

090

071

240

010

032

220

229

161

140

159

405

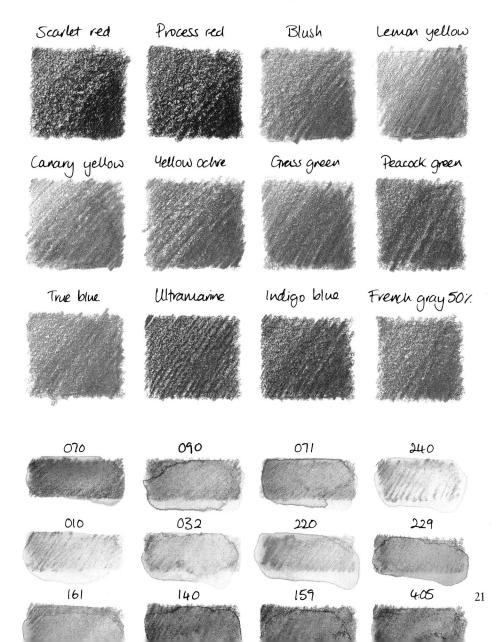

| Scarlet red | Process red | Blush | Lemon yellow |

| Canary yellow | Yellow ochre | Grass green | Peacock green |

| True blue | Ultramarine | Indigo blue | French gray 50% |

| 070 | 090 | 071 | 240 |

| 010 | 032 | 220 | 229 |

| 161 | 140 | 159 | 405 |

21

Apple green – 221

Scarlet red	Process red	Blush	Lemon yellow

Canary yellow	Yellow ochre	Grass green	Peacock green

True blue	Ultramarine	Indigo blue	French gray 50%

070	090	071	240

010	032	220	229

161	140	159	405

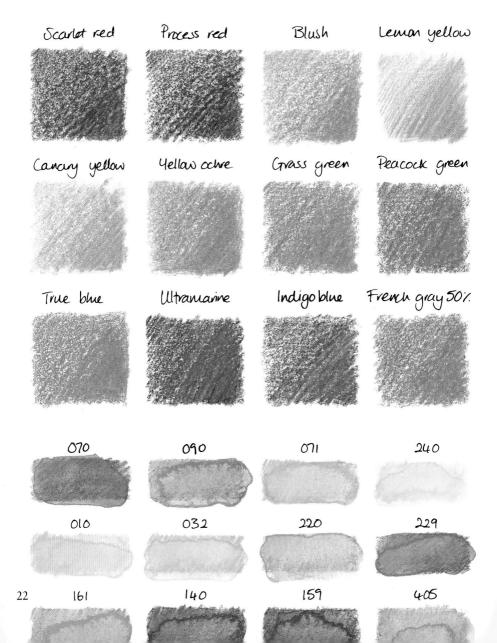

Scarlet red	Process red	Blush	Lemon yellow
Canary yellow	Yellow ochre	Grass green	Peacock green
True blue	Ultramarine	Indigo blue	French gray 50%

070	090	071	240
010	032	220	229
161	140	159	405

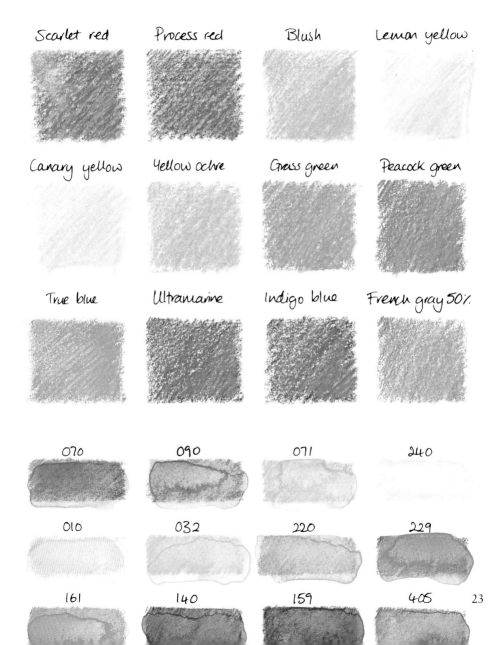

Mixing greens

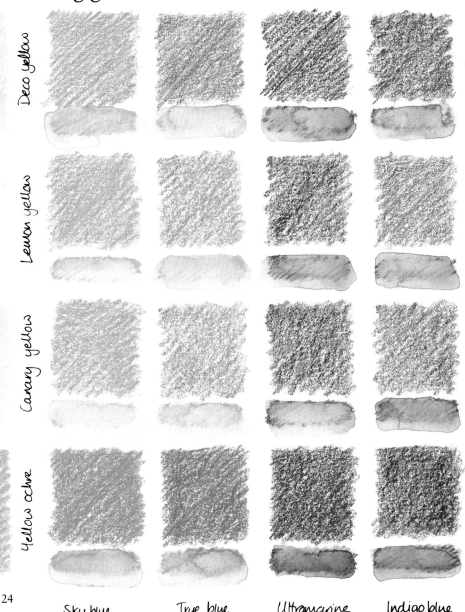

Deco yellow

Lemon yellow

Canary yellow

Yellow ochre

Sky blue

True blue

Ultramarine

Indigo blue

The pigment ratios for both sets of charts have been chosen to produce the best results. For the equivalent colors in water-soluble pencil see Contents page.

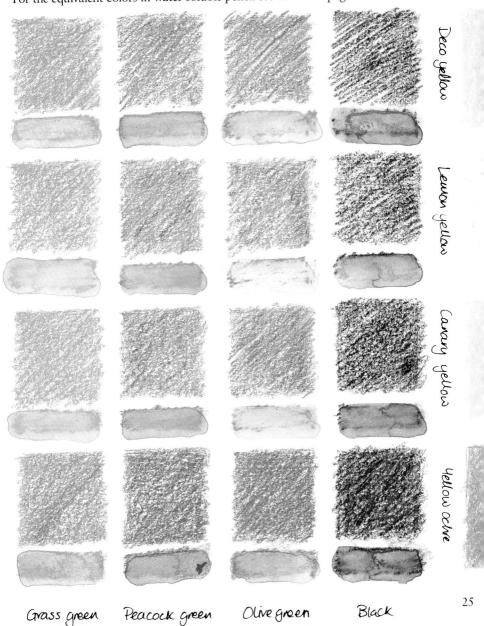

Deco yellow

Lemon yellow

Canary yellow

Yellow ochre

Grass green

Peacock green

Olive green

Black

USING GREENS

Jane Strother – *Muscadet Region*

8 × 6 ins approximately

THE FRESH SPRING atmosphere in this view of vineyards has been conveyed by using a unified palette of cool blues, violet and greens with some warm but light pinks and ochres. For the greens, true blue, blush and grass green were lightly shaded before more detailed drawing was done in stronger tones. Careful water washes blend colors and "knock back" shadows.

▶ For the strong shadows under the eaves, violet washed with water has been laid over blush and yellow ochre. Pale orange pencil highlights the sunlit wall, and white areas are accentuated with gouache paint or diluted with a thin violet wash.

▼ The stones in the wall have been shaded with blush, yellow ochre and olive green. The shadows are drawn in indigo and peacock green, and the whole area softened with a light wash.

▲ Loose drawing follows the form of the road, giving movement to the foreground. The broad, grainy marks made in yellow ochre, deco yellow and olive green are blended with water. Heavier pressure with a blue-violet pencil has been used for the shadow.

◀ Peacock green, indigo and grass green describe the form of the tree. Flecks of the underlying blush show through the foliage, creating a link between the tree and the receding fields.

26

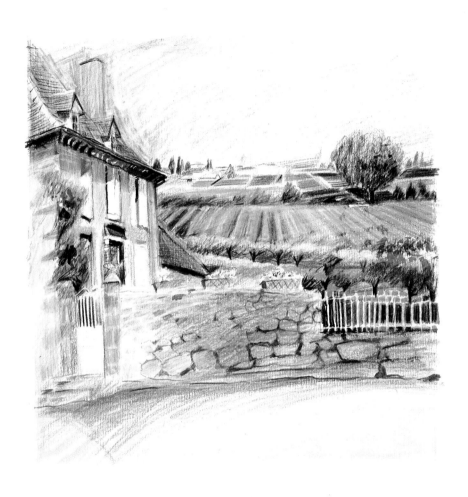

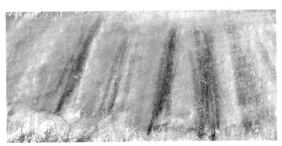

◄*The purple shadows recede quite dramatically and the green stripes "come forward", thus achieving the effect of a vineyard by the use of color alone. Blush has been used beneath these colors, unifying this area with the rest of the landscape.*

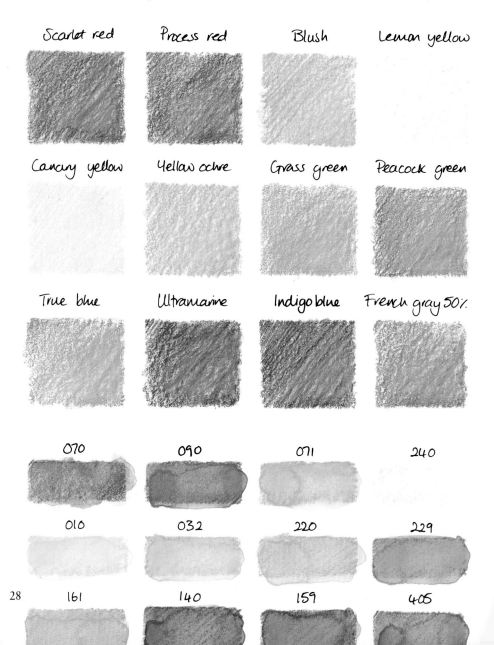

Scarlet red

Process red

Blush

Lemon yellow

Canary yellow

Yellow ochre

Grass green

Peacock green

True blue

Ultramarine

Indigo blue

French gray 50%

070

090

071

240

010

032

220

229

161

140

159

405

Canary yellow – 010

Scarlet red	**Process red**
Blush	**Lemon yellow**
Canary yellow	**Yellow ochre**
Grass green	**Peacock green**
True blue	**Ultramarine**
Indigo blue	**French gray 50%**

070	090	071	240
010	032	220	229
161	140	159	405

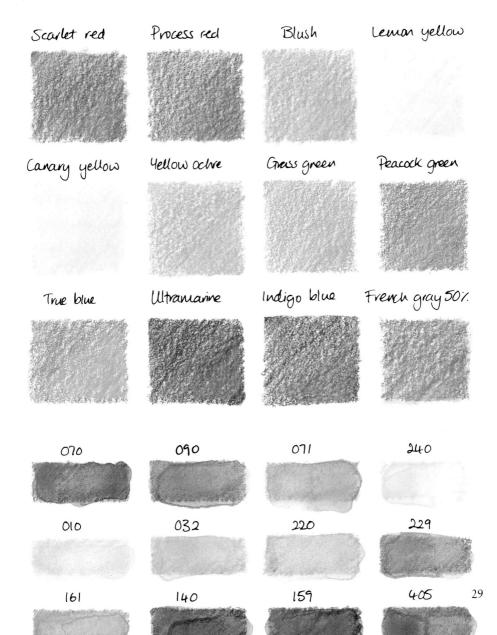

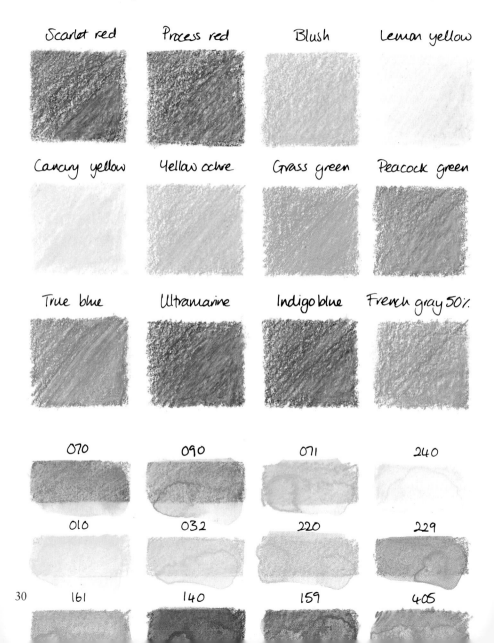

Scarlet red	Process red	Blush	Lemon yellow
Canary yellow	Yellow ochre	Grass green	Peacock green
True blue	Ultramarine	Indigo blue	French gray 50%
070	090	071	240
010	032	220	229
161	140	159	405

Yellow ochre – 032

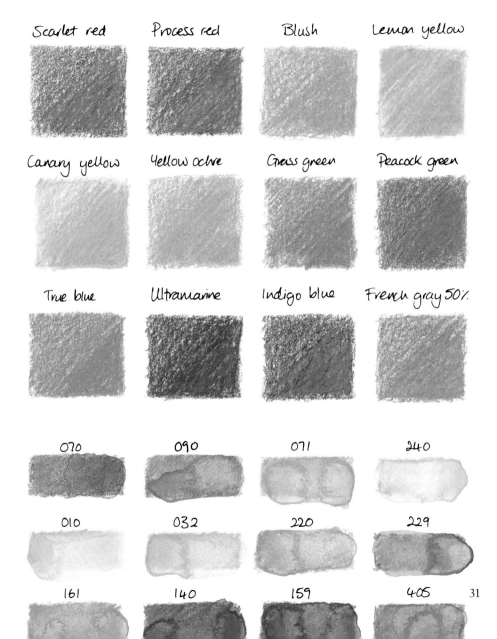

Scarlet red

Process red

Blush

Lemon yellow

Canary yellow

Yellow ochre

Grass green

Peacock green

True blue

Ultramarine

Indigo blue

French gray 50%

070

090

071

240

010

032

220

229

161

140

159

405

31

Golden rod – 035

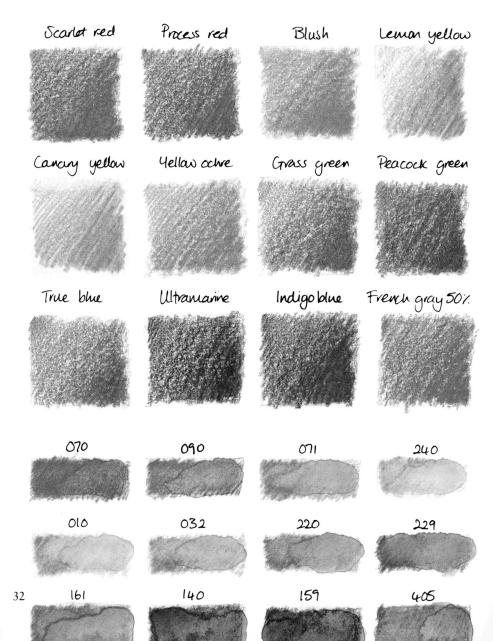

Scarlet red	Process red	Blush	Lemon yellow
Canary yellow	Yellow ochre	Grass green	Peacock green
True blue	Ultramarine	Indigo blue	French gray 50%
070	090	071	240
010	032	220	229
161	140	159	405

Pumpkin orange – 062

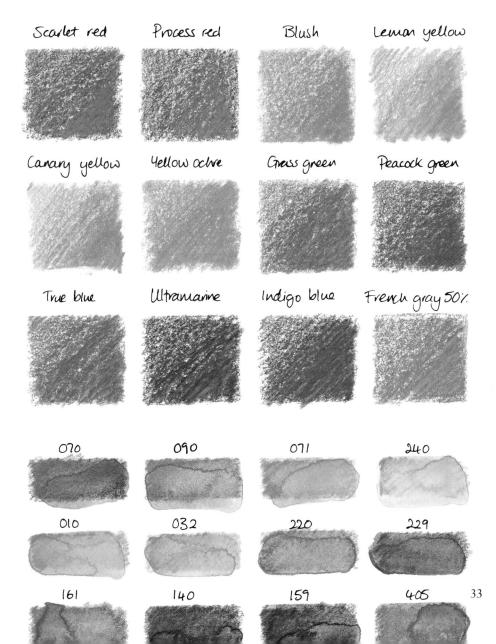

Scarlet red

Process red

Blush

Lemon yellow

Canary yellow

Yellow ochre

Grass green

Peacock green

True blue

Ultramarine

Indigo blue

French gray 50%

070

090

071

240

010

032

220

229

161

140

159

405

Mixing oranges

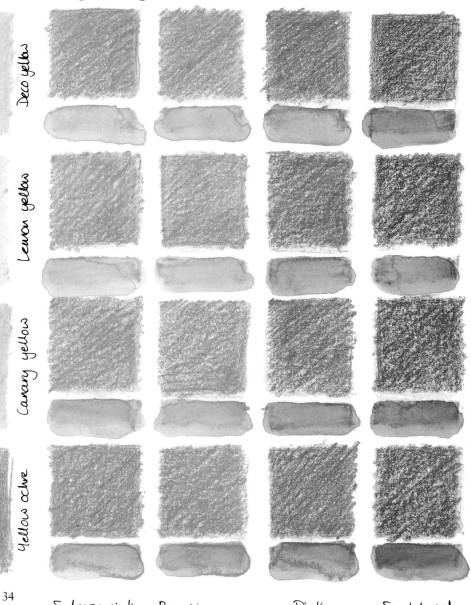

Deco yellow

Lemon yellow

Canary yellow

Yellow ochre

34

Salmon pink Pumpkin orange Pink Scarlet red

The pigment ratios for both sets of charts have been chosen to produce the best results. For the equivalent colors in water-soluble pencil see Contents page.

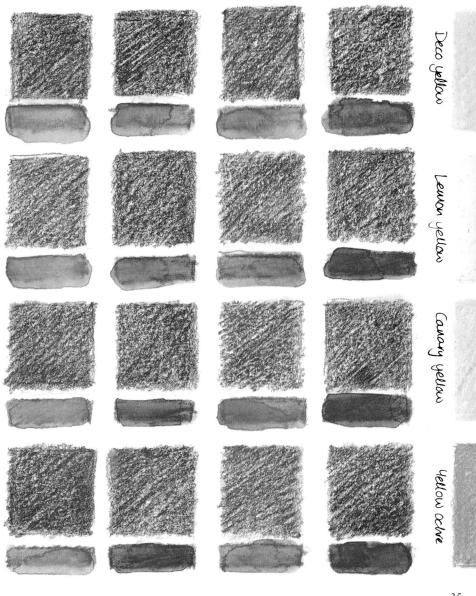

Deco yellow

Lemon yellow

Canary yellow

Yellow ochre

Process red Crimson red Terracotta Raspberry

USING BRIGHT COLORS

Jane Hughes – *Pinboard*

23 × 16¼ ins

IN THIS DETAILED drawing of a cluttered pinboard the artist has used a large palette of colors straight from the box, with color mixing kept to a minimum. Where a range of vivid colors is required it is not always practical to rely on mixing, which typically provides more subtle effects. Various methods have been employed to build up different textures and surfaces, from the subtle shading used for the transparent wrapper to the dense, flat areas of color which represent opaque printed color.

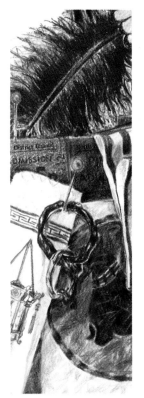

◀*The dominant color in this part of the picture is noticeably red, with several different hues used. Shadows are created with darker reds, with touches of blue and brown. The light, fluffy texture of the feather has been wonderfully captured with sensitive manipulation of the pencil.*

▶*The highlights on the transparent wrapper have been created by using an eraser, a method which is only really successful on lightly pencilled areas. The careful shading on this, the most three-dimensional object in the picture, contrasts with the flatly applied color elsewhere.*

 # Salmon pink – 051

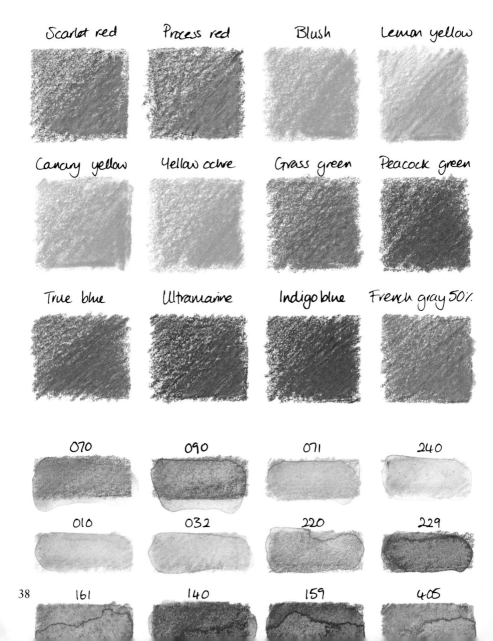

Scarlet red	Process red	Blush	Lemon yellow
Canary yellow	Yellow ochre	Grass green	Peacock green
True blue	Ultramarine	Indigo blue	French gray 50%
070	090	071	240
010	032	220	229
161	140	159	405

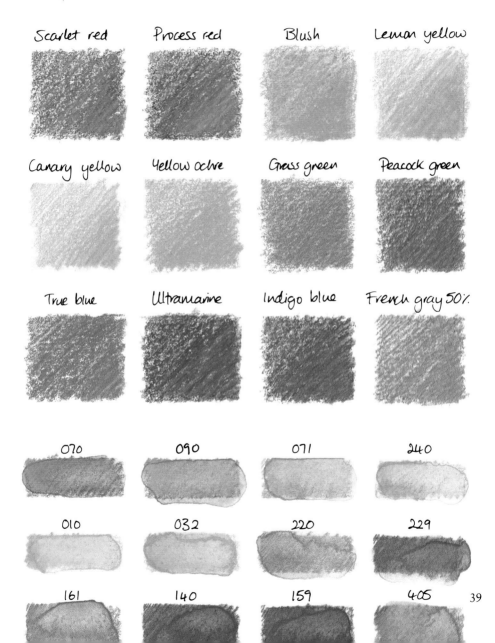

Scarlet red

Process red

Blush

Lemon yellow

Canary yellow

Yellow ochre

Grass green

Peacock green

True blue

Ultramarine

Indigo blue

French gray 50%

070

090

071

240

010

032

220

229

161

140

159

405

39

Rosy beige – 403

Scarlet red	Process red	Blush	Lemon yellow
Canary yellow	Yellow ochre	Grass green	Peacock green
True blue	Ultramarine	Indigo blue	French gray 50%

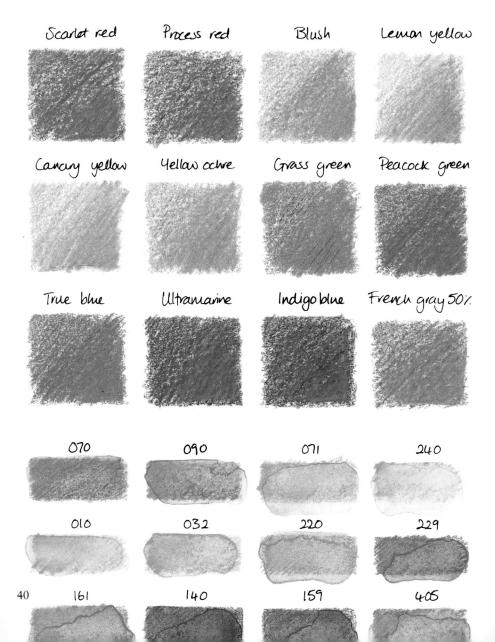

070	090	071	240
010	032	220	229
161	140	159	405

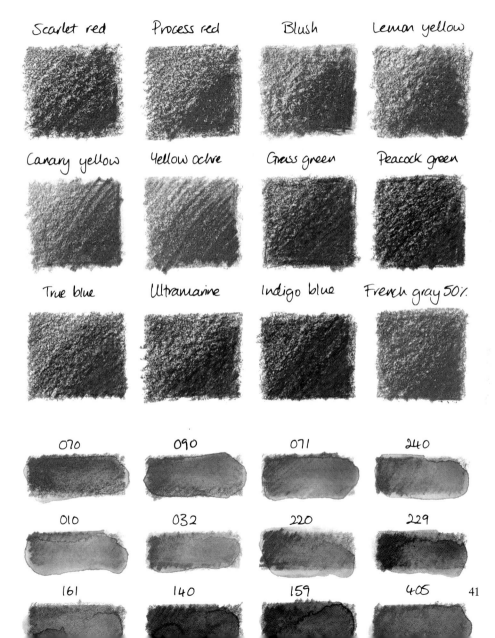

| Scarlet red | Process red | Blush | Lemon yellow |

| Canary yellow | Yellow ochre | Grass green | Peacock green |

| True blue | Ultramarine | Indigo blue | French gray 50% |

| 070 | 090 | 071 | 240 |

| 010 | 032 | 220 | 229 |

| 161 | 140 | 159 | 405 |

 # Crimson red – 080

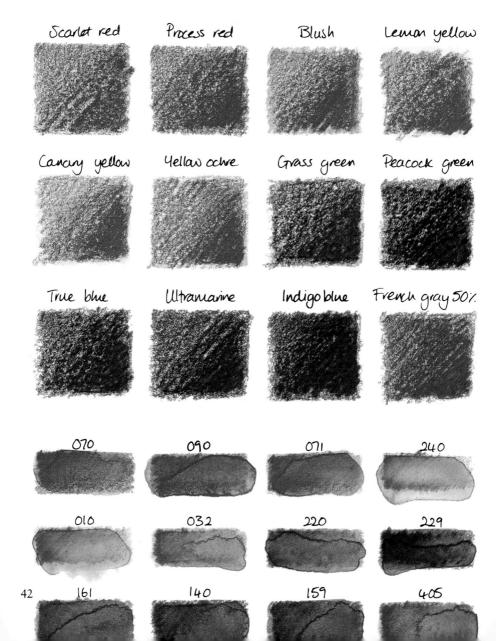

| Scarlet red | Process red | Blush | Lemon yellow |

| Canary yellow | Yellow ochre | Grass green | Peacock green |

| True blue | Ultramarine | Indigo blue | French gray 50% |

| 070 | 090 | 071 | 240 |

| 010 | 032 | 220 | 229 |

| 161 | 140 | 159 | 405 |

42

Scarlet red	Process red	Blush	Lemon yellow

Canary yellow	Yellow ochre	Grass green	Peacock green

True blue	Ultramarine	Indigo blue	French gray 50%

070	090	071	240

010	032	220	229

161	140	159	405

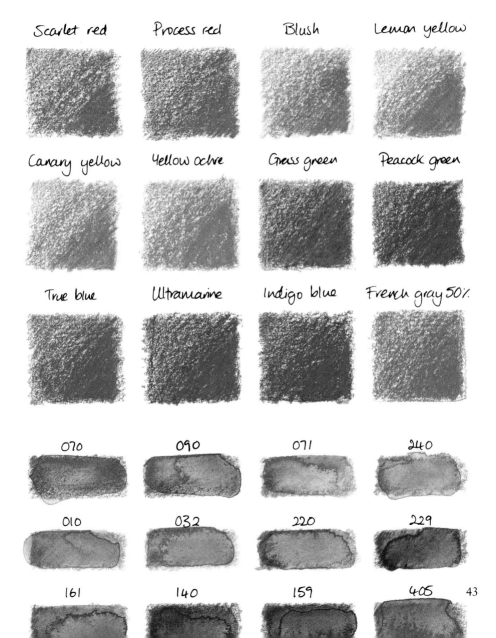

 # Raspberry – 085

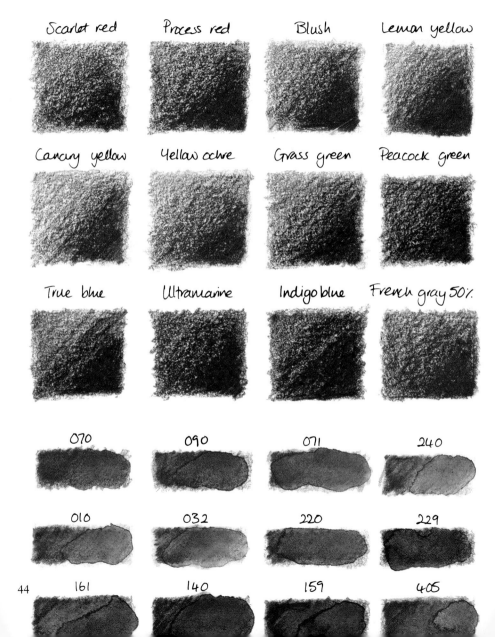

Scarlet red

Process red

Blush

Lemon yellow

Canary yellow

Yellow ochre

Grass green

Peacock green

True blue

Ultramarine

Indigo blue

French gray 50%

070

090

071

240

010

032

220

229

44

161

140

159

405

Process red – 090

Scarlet red	Process red	Blush	Lemon yellow
Canary yellow	Yellow ochre	Grass green	Peacock green
True blue	Ultramarine	Indigo blue	French gray 50%

070	090	071	240
010	032	220	229
161	140	159	405

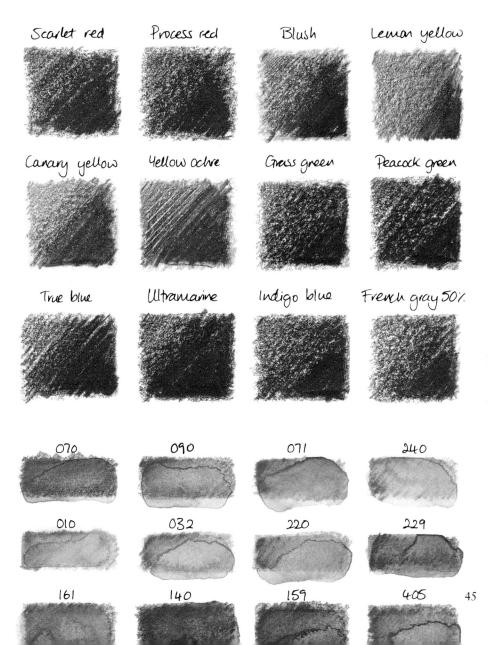

 # Light violet – 111

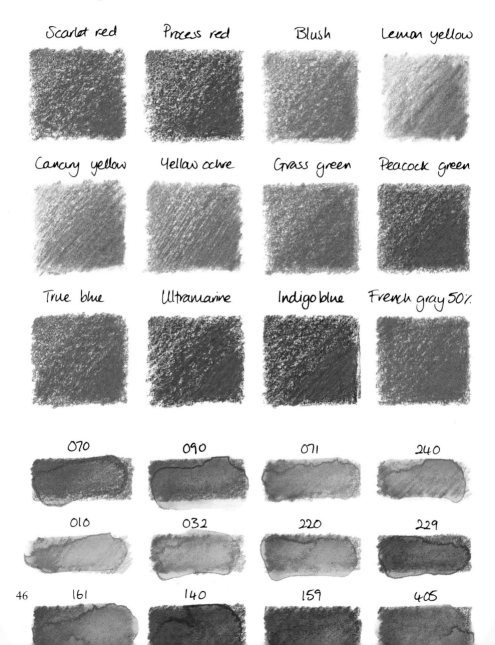

Scarlet red

Process red

Blush

Lemon yellow

Canary yellow

Yellow ochre

Grass green

Peacock green

True blue

Ultramarine

Indigo blue

French gray 50%

070

090

071

240

010

032

220

229

161

140

159

405

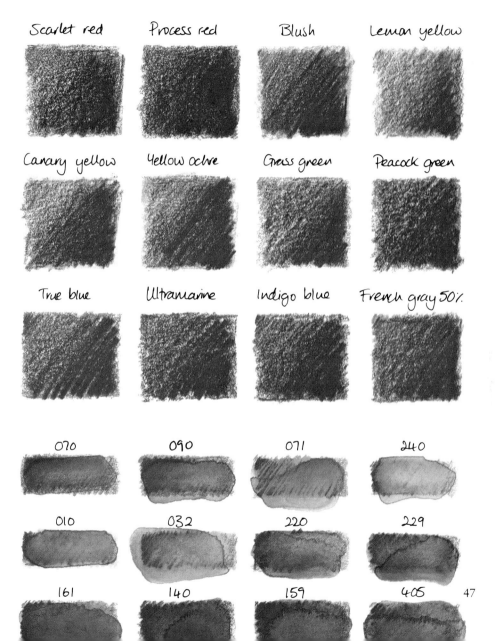

Scarlet red

Process red

Blush

Lemon yellow

Canary yellow

Yellow ochre

Grass green

Peacock green

True blue

Ultramarine

Indigo blue

French gray 50%

070

090

071

240

010

032

220

229

161

140

159

405

Mixing purples

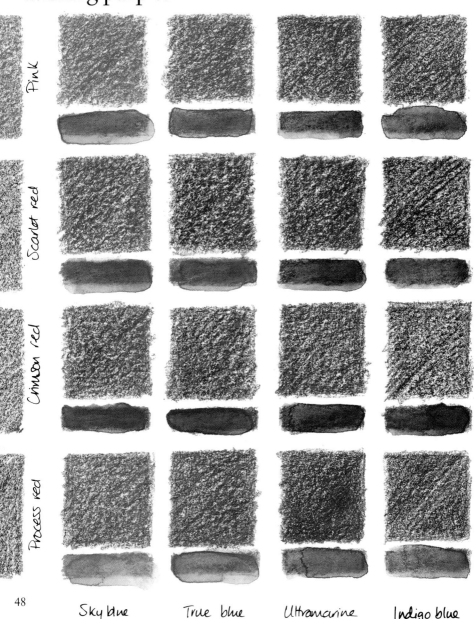

Pink

Scarlet red

Crimson red

Process red

Sky blue True blue Ultramarine Indigo blue

The pigment ratios for both sets of charts have been chosen to produce the best results.
For the equivalent colors in water-soluble pencil see Contents page.

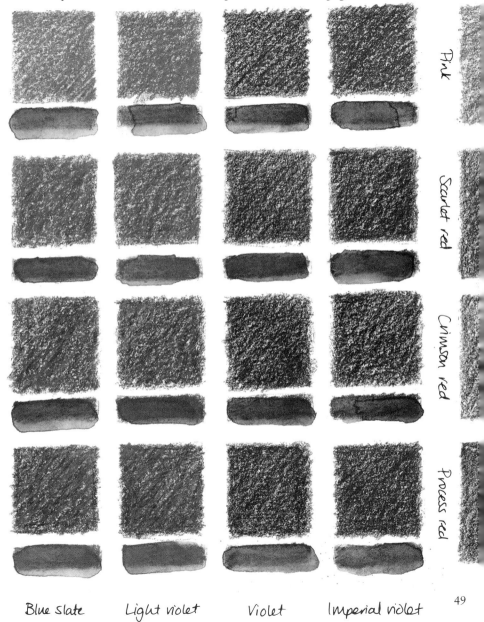

Pink

Scarlet red

Crimson red

Process red

Blue slate Light violet Violet Imperial violet

Optical Mixing

Carl Melegari – *Street Walking*

20 × 15 ins

WHEN TWO COLORS which are close in tone are laid down next to each other they merge in the eye and read as one color. The artist has made exciting use of this principle, building up wonderfully vivid and shimmering colors with close diagonal strokes. This vigorous use of the pencils, together with the free, flowing outlines of the figures, gives an excellent impression of movement.

▶ *The darkest colors have been achieved by the addition of black, but several other colors have been used beneath and allowed to show through. Viewed on its own, this detail of the picture looks like nothing more than a set of stripes; optical mixing relies on the context as well as a degree of distance.*

◀ *It is fascinating to see the number of colors used here. Although the eye reads the figure as red, there are blues, blue-greens and yellows as well as reds, violets and pinks.*

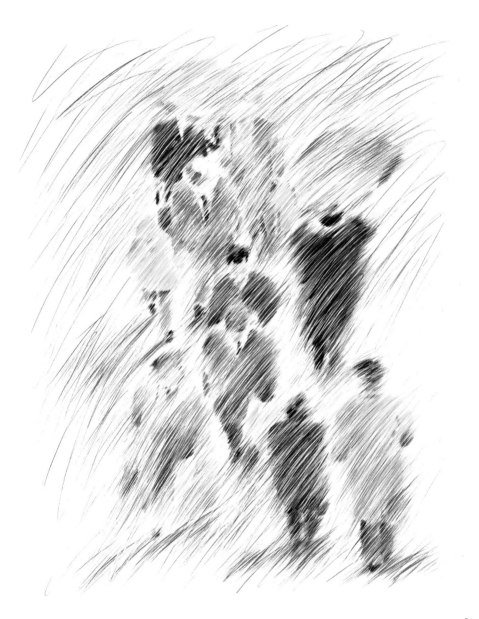

 # Burnt umber – 409

Scarlet red	Process red	Blush	Lemon yellow
Canary yellow	Yellow ochre	Grass green	Peacock green
True blue	Ultramarine	Indigo blue	French gray 50%

070	090	071	240
010	032	220	229
161	140	159	405

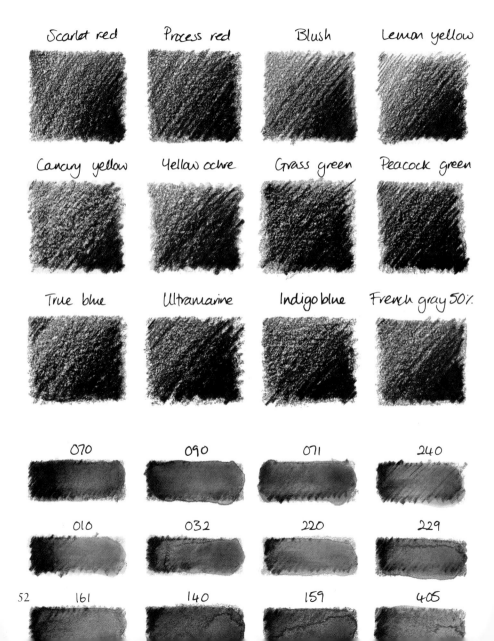

Sienna brown – 059

Scarlet red	Process red	Blush	Lemon yellow
Canary yellow	Yellow ochre	Grass green	Peacock green
True blue	Ultramarine	Indigo blue	French gray 50%

070	090	071	240
010	032	220	229
161	140	159	405

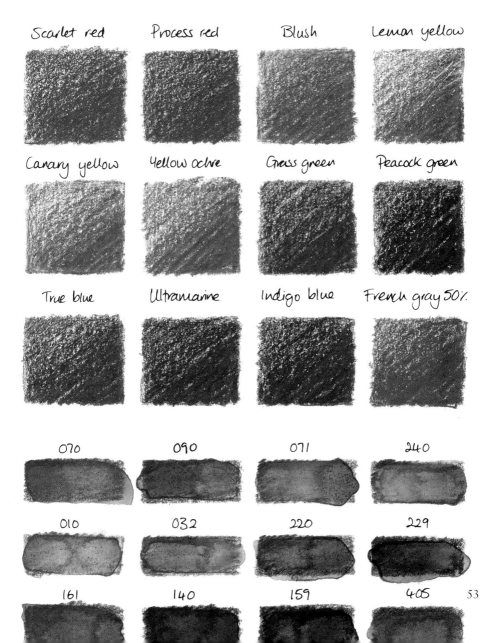

 # Terracotta – 065

Scarlet red

Process red

Blush

Lemon yellow

Canary yellow

Yellow ochre

Grass green

Peacock green

True blue

Ultramarine

Indigo blue

French gray 50%

070

090

071

240

010

032

220

229

161

140

159

405

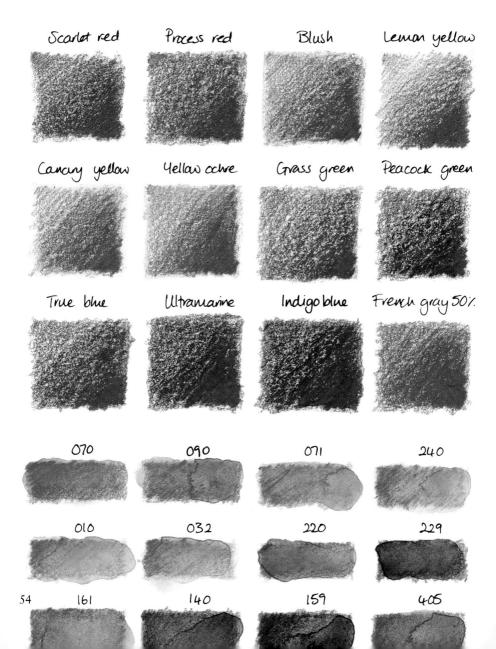

Bronze – 025

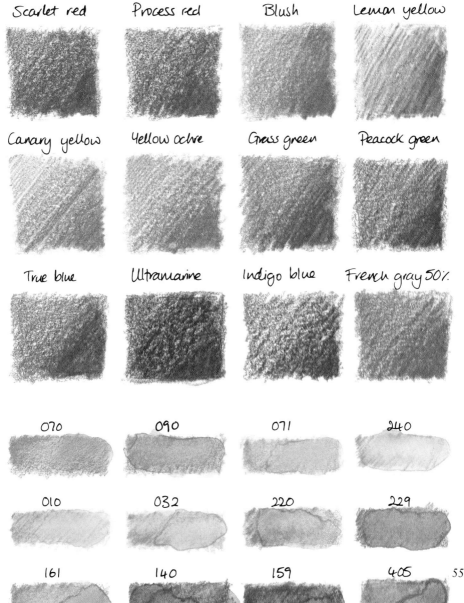

Scarlet red

Process red

Blush

Lemon yellow

Canary yellow

Yellow ochre

Grass green

Peacock green

True blue

Ultramarine

Indigo blue

French gray 50%

070

090

071

240

010

032

220

229

161

140

159

405

Mixing browns: two colors

The pigment ratios for both sets of charts have been chosen to produce the best results.

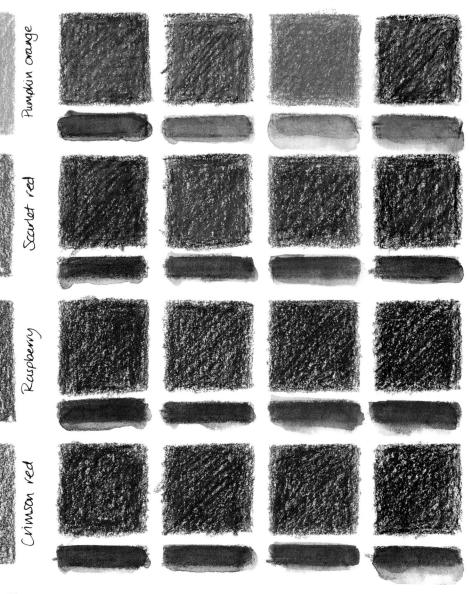

Pumpkin orange

Scarlet red

Raspberry

Crimson red

Ultramarine Burnt umber Grass green Black

Mixing browns: three colors

For the equivalent colors in water-soluble pencil see Contents page.

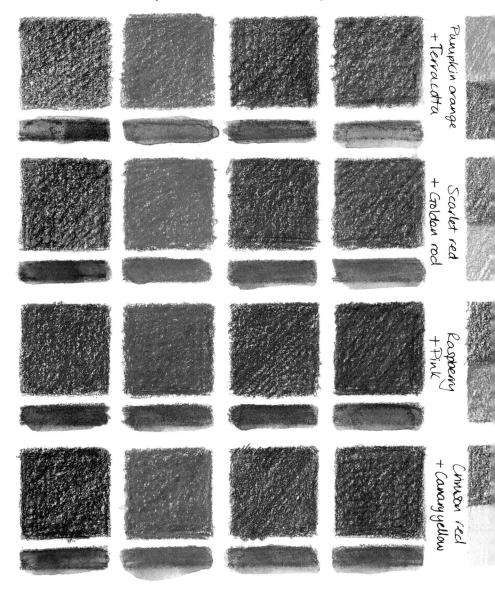

Pumpkin orange + Terracotta

Scarlet red + Golden rod

Raspberry + Pink

Crimson red + Canary yellow

Indigo blue French gray 50%. Violet Olive green

USING DARK COLORS

Phil Wildman – *Backstreet Football*

23 × 33 ins approximately

ALTHOUGH THE COLORS are all relatively dark they are far from somber, and the eye is drawn immediately to the rich red-brown of the sunlit wall and the vivid blue of the sky. The wall is the focal point of the picture, and is more "worked-up" than other areas. The foreground, although well observed, remains sketchy, allowing the eye to pass over and above it to the buildings themselves.

◀ *The end wall is in deep shadow, and the pencil has been built up thickly, with overlays of blue, brown and black very slightly graded towards the bottom. Here again the blind impressing method has been used to describe the slant of the roof tiles, and the directional strokes used for the sky give an attractive sense of movement.*

▼ *The browns and rusts in this area are dense and vibrant, complemented by the deep, dark blue of the roof. The shadow of the chimney, an important part of the composition, has been created by laying a darker brown over the rich rust color.*

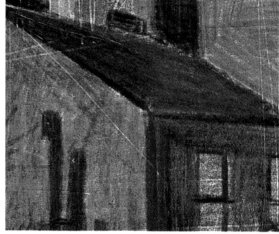

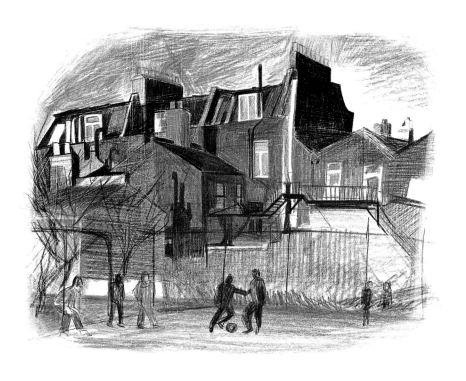

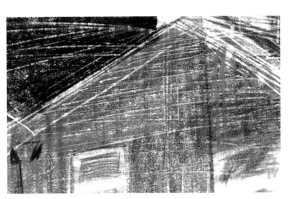

◀ *In some areas of the picture the artist has used a method called blind impressing, in which lines are made by drawing or scribbling on the paper with a point. These remain white when shaded over. Here the technique has allowed him to suggest the texture of the wall.*

French gray 50% — 405

Scarlet red	Process red	Blush	Lemon yellow

Canary yellow	Yellow ochre	Grass green	Peacock green

True blue	Ultramarine	Indigo blue	French gray 50%

070	090	071	240

010	032	220	229

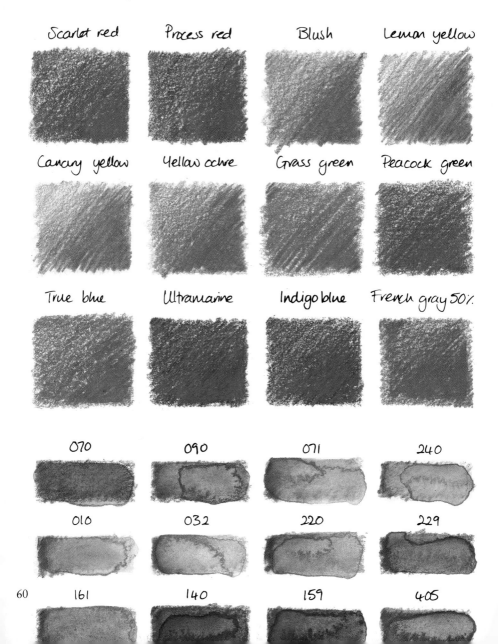

161	140	159	405

Cool gray 50% — 005

Scarlet red	Process red	Blush	Lemon yellow
Canary yellow	Yellow ochre	Grass green	Peacock green
True blue	Ultramarine	Indigo blue	French gray 50%

070	090	071	240
010	032	220	229
161	140	159	405

Black – 009

Scarlet red	Process red	Blush	Lemon yellow
Canary yellow	Yellow ochre	Grass green	Peacock green
True blue	Ultramarine	Indigo blue	French gray 50%
070	090	071	240
010	032	220	229
161	140	159	405

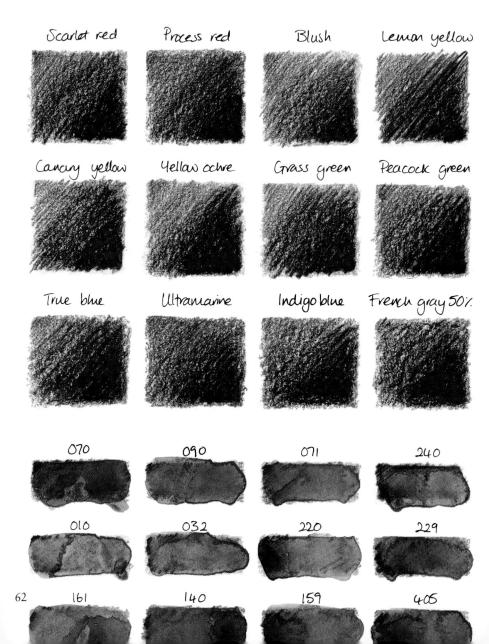

Scarlet red

Process red

Blush

Lemon yellow

Canary yellow

Yellow ochre

Grass green

Peacock green

True blue

Ultramarine

Indigo blue

French gray 50%

070

090

071

240

010

032

220

229

161

140

159

405

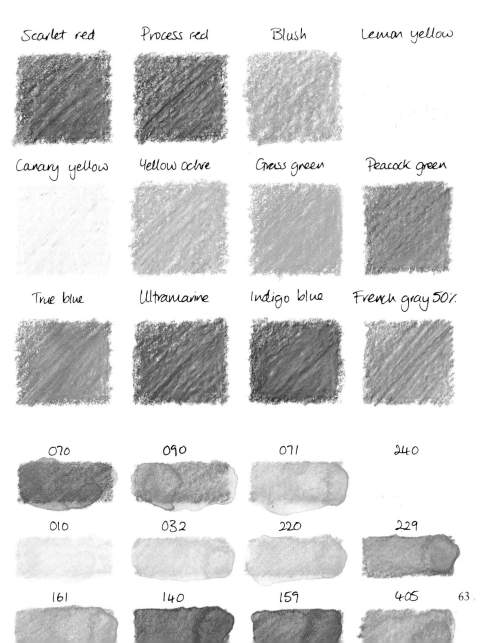

CREDITS

CONTRIBUTING ARTISTS
16 Sue Lines; **26** Jane Strother; **36** Jane Hughes;
50 Carl Melegari; **58** Phil Wildman

Senior Editor
Hazel Harrison

Art Director
Moira Clinch

Designer
Clare Baggaley

Typeset by West End Studios, Eastbourne
Manufactured by Bright Arts (Singapore) Pte. Ltd.
Printed in Singapore by Tien Wah

The publishers would like to thank
Berol and Caran d'Ache for kindly supplying
the materials for this book